Positive Thinking for Positive Living

Positive Thinking for Positive Living

Rowena Kong

Y. Ho (Photography)

2019
Rowena Kong

Copyright © 2019 by Rowena Kong

All rights reserved. This book or any portion thereof may not be reproduced or used in any manner whatsoever without the express written permission of the publisher except for the use of brief quotations in a book review or scholarly journal.

First Printing: 2019

ISBN: 9781082277535

As a teacher, I guide and correct,
As a writer, I plan and tell,
As a dreamer, I imagine and prove,
As a leader, I think and speak,
As a speaker, I utter and reveal,
As a family, I care and provide,
As a grower, I plant and wait,
As a harvester, I collect and divide,
As a planner, I draw and organise,
As a thinker, I consider and argue,
As a student, I learn and improve,
As a listener, I heed and understand,
As a companion, I help and console,
As a human, I feel and love,
And create my legacy...

My name speaks of a reputation and lends a mesage of hope..

It secures a hallmark of success and extends the connection of love..

It is a pillar of wisdom and minds the hurts of the unfortunate.

It shines honour on my family and brings courage to the faint-hearted.

My Name is a Legacy which I can create for the better of this world...

Some seek riches… Others seek fame… Still others seek acceptance and mindfulness… But, I seek wisdom…The wisdom to tell what is right from wrong. The wisdom to understand and divide the nature of motives in others. The wisdom to appreciate the beauty of wholeness and uniqueness of the good things, The wisdom to correct the wrong and restore the losses of time. The wisdom to align with the hope of the better for tomorrows and plan ahead with diligence and precision. The wisdom to understand the unspoken hurts of others and aid the efforts of the weak and unfortunate. The wisdom to heal the brokenness of an affliction and ease the distress of a suffering. The wisdom to guide and teach the hearts of the willing and curious…Most of all, the wisdom to give, favour and love the unloved…

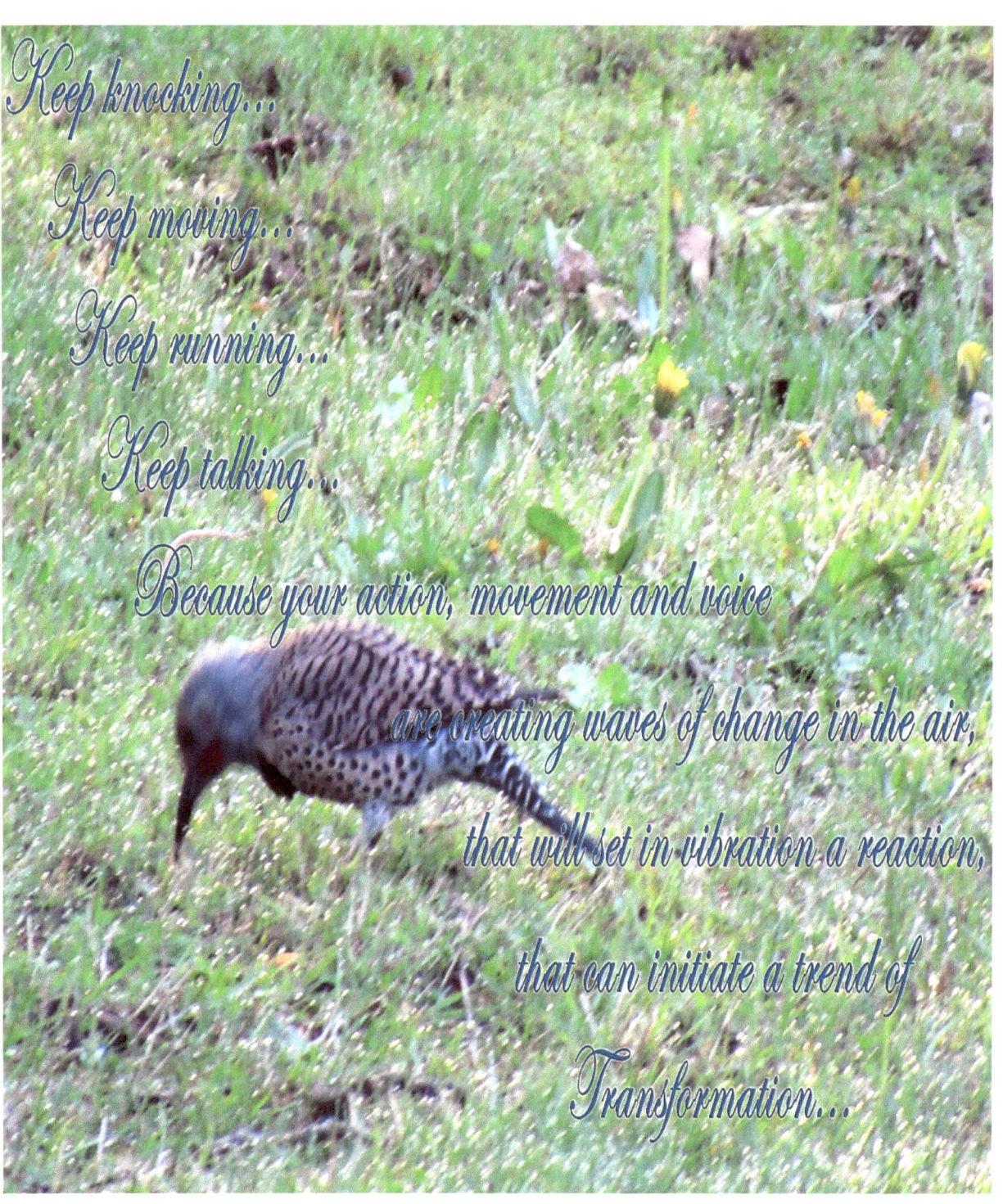

Keep knocking...

Keep moving...

Keep running...

Keep talking...

Because your action, movement and voice

are creating waves of change in the air,

that will set in vibration a reaction,

that can initiate a trend of

Transformation...

Life...

is not simply a race to run...

It is also a marathon to endure and persevere...

Time,
may not heal all hurts...

But,

it can dry my tears,
and drive away the
shadows,
soothe my wounds,
listen to my cries,
calm my fears,
send the butterfly,
colour the fields,
halt the rain,
call forth the sunshine,
and bring me my
Rainbows...

Smiles and tears
are the unspoken
expressions of love...

Love is a neverending string...

*We learn from the past.
Its mistakes may be plentiful,
but they help build up
our resilience and endurance,
to see past their brokenness
into their hopefulness and beauty.*

Love guides us to the right dreams.
Dreams lead us to the right hope.
Hope brings us to the right faith.
Faith takes us to the right world…

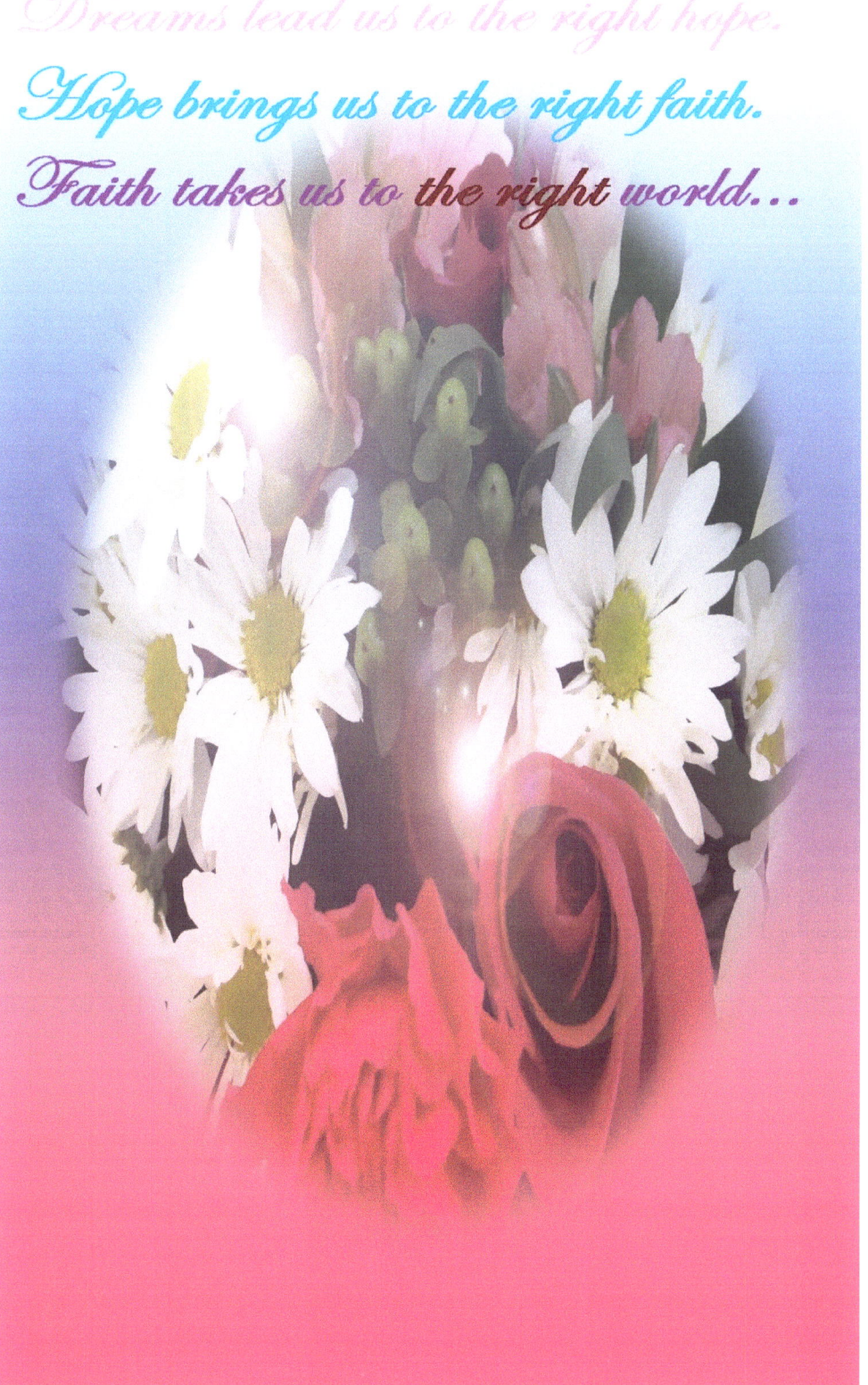

Other Titles by the Author:

1. Handy Health and Life Tips

What to avoid while having the common cold? Why do we crave for sweet drinks during an intense thirst? What makes the eucalyptus oil an extraordinary remedy? Read about these in this book of handy health tips for better living.

2. Learning About Dopamine

As the popular neurotransmitter, why do we need dopamine and how does it help us in promoting our health and treatment of disorders? Dopamine does not simply reside within our brains but its presence extends to the cells of our immune system and even the renal organ. Read about dopamine's role in blood pressure regulation and sustaining our reward sensitivity and perception of positivity in life from the topics covered. Also included are the implication of dopamine's role in drug abuse recovery and a brief discussion of the challenges involved in the use of dopamine agonists and the potential frontier of transporter agonists/reuptake enhancers for depression and schizophrenia treatments respectively.

3. Rethinking Science, Research and Technology

We are now in an age of booming science and technology where their influence pervades almost every area of our lives. How do we make sense of it all? Is it possible that science, research, and technology, in all their amazing glory and capabilities, can set an invisible constraint on and limit the potential of our creativity and appreciation of the beauty of life? We may be the 21st century masters of technology, but are we the masters of happiness and our fundamental autonomy? Our implicit perspective of the ongoing high-paced acceleration of scientific and technological development has a place in cautioning their subtle increasing demands and control placed over our daily routine, health and well-being. Research is also increasingly garnering the attention of academics and the public. With an unprecedented surge in the amount of studies being carried out round the clock in post-secondary institutions, a question arises as to whether such trend mirrors our overutilization of research and its resources. Perhaps, it is about time to step back and subjectively weigh both the benefits and costs of the current trend of our growing reliance on such unprecedented sophistication and advancement.

www.ingramcontent.com/pod-product-compliance
Lightning Source LLC
Chambersburg PA
CBHW041320180526
45172CB00004B/1170